THIS COLORING BOOK BELONGS TO:

Thank you for choosing
our book
We hope you liked it.
As a small family company
your feedback is very
important to us, please leave
your review at
ms.dodon@mail.ru

CPSIA information can be obtained
at www.ICGtesting.com
Printed in the USA
BVHW052139250621
610374BV00013B/1987